# The Well-Bred
# DOG

# The Well-Bred DOG

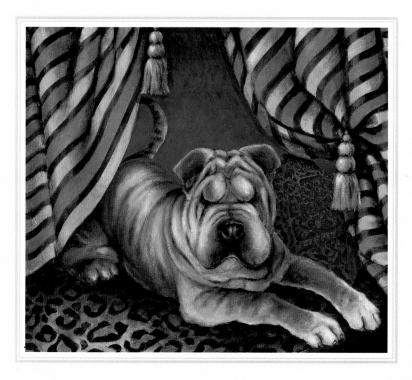

## Lisa Zador's Collection of Curious Canines

### Stories by James Waller

Stewart, Tabori & Chang
New York

Published by
Stewart, Tabori & Chang
A Company of La Martinière Groupe
115 West 18th Street
New York, NY 10011

Export Sales to all countries except Canada, France,
and French-speaking Switzerland:
Thames and Hudson Ltd.
181A High Holborn
London WC1V 7QX
England

Canadian Distribution:
Canadian Manda Group
One Atlantic Avenue, Suite 105
Toronto, Ontario M6K 3E7
Canada

ISBN: 1-58479-252-3

The text of this book was composed in Adobe Garamond.

Printed in Hong Kong

10 9 8 7 6 5 4 3 2 1

First Printing                                          Designed by Jay Anning, Thumb Print

To
## TOBY AND BINGO

# PREFACE

LISA ZADOR INHABITS THE SAME WORLD AS THE REST OF US—a world where human beings and animals constantly interact: loving each other, offering selfless companionship, sometimes understanding each other very well (and sometimes decidedly not), and occasionally getting on one another's nerves like nobody's business. But Lisa's depictions of our four-legged friends also turn our own, familiar world squarely on its ear. In the bizarre parallel universe her pictures record, dogs and human beings continue to relate—but now they do so as equals. The results are charming, hilarious, and maybe a bit unsettling.

Lisa's not the first animal painter to have dressed her subjects up in people's clothes or placed them in distinctly human settings. But she's taken this strange little genre to a much more interesting—and entertaining—level. The conception of each of her pictures—the content *and* the style—grows out of her response to the dog-sitter's own personality. (The dogs she portrays are all real, live animals—two are the painter's own companions; others belong to friends; and some are waiting for homes in a New York City shelter. The actual names of the models—and of their owners—appear at the end of this book.) Lisa's paintings aren't cartoons or mere "illustrations"; they're real *portraits,* often as revelatory of character as we expect pictures of people to be. Sure, some of the images are silly; but what's striking is that they're all so *good.*

For me, working with Lisa on this book has been an unmixed pleasure. Adopting the pose of art critic and (unrepentantly punning) raconteur, I've been as inspired by Lisa's pictures as she is by the animals she paints. The assignment has been a writer's dream—transporting me out of my ordinary world of dogsbody drudgery into a rarefied realm, where I've rubbed elbows with the great (Danes, Pyrenees) and the fetching, and where I've had the privilege of meeting her elite clientele—artists, scientists, models, culture mavens—muzzle to muzzle. I hope you'll have just as much fun reading the stories that accompany the paintings as I've had writing them.

So, without further ado, let's step into the looking-glass world of "Zador" and her curious canines.

—JAMES WALLER

# ZADOR'S
# WELL-BRED DOGS

Lisa Zador is best in her class. Today, Zador—always accompanied by her bosom pals, the look-alike Malteses Toby and Bingo—is seen cavorting with trendy setters the world over. Her every movement, it seems, is tracked by the puppy-razzi. Among an ever-widening circle of status

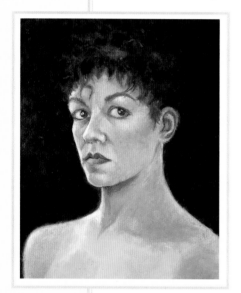

seekers, inviting friends over for the unveiling of a portrait by Zador has become the surest, most impressive way of putting on the dog. If you haven't heard of Zador—haven't desired to have your image captured by her brush—why, you must live in Dogpatch.

It wasn't always so. Like many artists, Zador has had to struggle. Her long road to success felt, at many points, like an Iditarod. After training at the École des Beaux-Arts, Zador experimented with a number of genres—dog-legging her way through landscape, still life, and pajama-fabric design. None really pleased her—and none brought her the renown her gifts deserved.

Then, one early-winter day a few years back, she was sitting on the sofa, fondly observing Toby napping in his little bed. Letting the sleeping dog lie, she dashed off a sketch for what would become a painting called *Doggie Dreams*. She realized immediately that the picture would make a perfect holiday card, so she had a few dozen printed and mailed them off to friends and acquaintances. They were a sensation, and one made its way into the paws of Hilda, the vain and regal dachshund who became Zador's first champion.

With Hilda as her intercessor, Zador's career blossomed like dogwood after April rain. Soon, a sitting at Zador's Greenwich Village studio had become a de rigueur rite of passage for the Westminster set. There, they'd surely see (and be bow-wowed by) the stacks of canvases at various stages of completion—a *Voyage of the Beagle,* a *Mother and Pup,* a *Temptation of Saint Bernard.* Orders from the highest pitches of international dogdom poured in, and Zador began bounding from continent to continent in service of her clientele. (Toby and Bingo tagged along, of course—for to know Zador is to know and love her little dogs, too.)

That's not to say that Zador ran to the whistle of money. Success gave her the opportunity to pursue her interest in notable dogs of the past (witness the portraits of Rosì, Beau, and Edwin, pages 14, 21, and 27 in this volume), and her fame gave her the credentials needed to convince even some highly reluctant celebs to pose for her (see *The Recluse,* page 43). And she took some real risks— the biggest being her decision, early on, to ignore the eternal "War Between the Species" and begin painting cats, as well. The jackals of the press leapt for the jugular, but ultimately that daring crossover move only enhanced her reputation.

Aesthetically, Zador is no dogmatist. She borrows freely from a wide range of styles, sometimes incorporating elements of classical portraiture—velvet swags, atmospheric landscapes, architectural dog-ends—into her canvases. Each setting, though, is carefully devised to reflect the personality of the subject. In fact, admirers say that what distinguishes Zador's portraits—beyond their evident technical merit—is the psychological insight they convey. "She truly lets the inner dog out," says one happy client.

Eagerly anticipated, *The Well-Bred Dog* gives us, at long last, the opportunity to explore the full scope of Lisa Zador's achievement—to appreciate the work in toto, as it were.

# HILDA

**O**THER COLLECTORS FOCUS ON SPECIFIC ARTISTS AND GENRES, but this lapdog of luxury amasses portraits of herself, in every conceivable manner, from every conceivable epoch.

The rooms in Hilda's digs resemble galleries in a particularly overstuffed museum. On a pedestal in the foyer stands Hilda as a rather low-slung replica of the Capitoline *She-Wolf*. The walls of her drawing room are plastered, floor to ceiling, with canvases: in one, Hilda crouches amid a company of Velázquez infantas; in another, Hilda—a Degas ballerina—prances *en pointe*; in a third, Hilda frolics nude among Cézanne bathers. The boudoir's crammed with facsimiles of modern masterpieces: over here, Hilda scurries along in a passable rendition of Balla's *Dynamism of a Dog on a Leash;* over there, Hilda slumps—looking more attenuated than ever—in the manner of a certain swaybacked Giacometti bronze. In the weirdest of all—a papier-mâché Oldenburg knockoff—Hilda is ensconced in a bun, slathered with bright-yellow mustard.

She was Zador's first patron. "Ziss time, I vant zumzink Oriental!" Hilda somewhat imperiously announced, on Zador's arrival. The painter knew immediately what she would do: Hilda's elegantly elongated torso made her the perfect model for an Ingres-style odalisque. The sessions were drawn-out affairs, interrupted by lunches of knockwurst and sour pickles.

The whole experience, Zador now reflects, was nerve-wracking, though finally worthwhile. "She grilled me about my plans," remembers Zador, "and it was really hard to get her to sit still." Afterward, though, Hilda was generous in introducing Zador around. The commissions began rolling in.

The rest is, as they say, arf history.

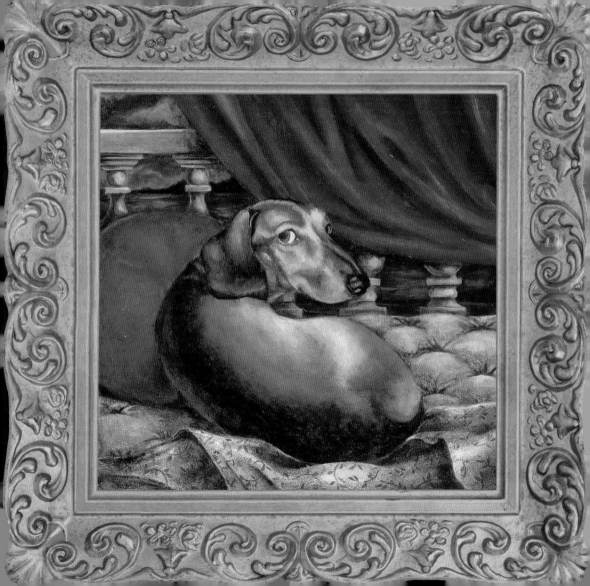

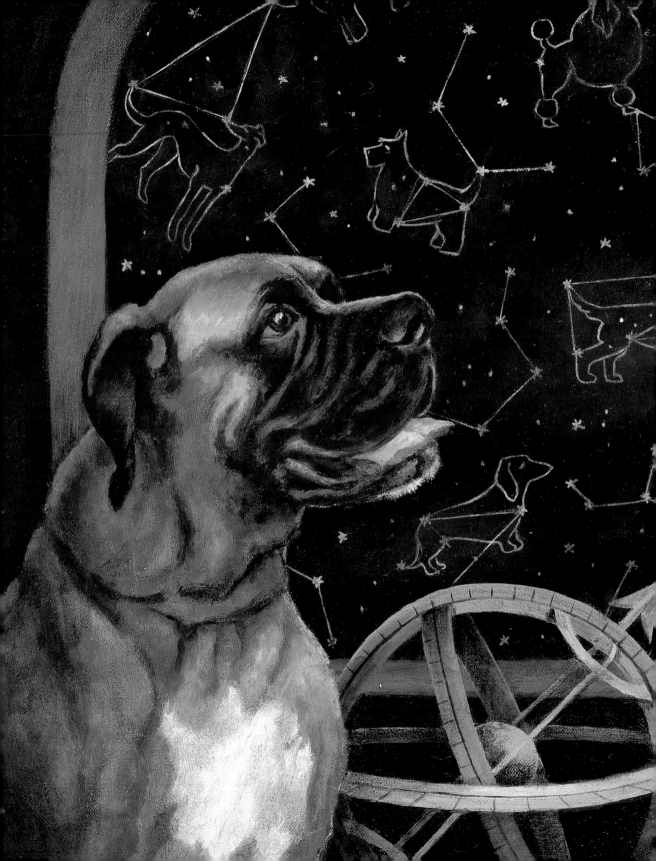

# HUMPHREY

STAR DOG OF THE INTERNATIONAL ASTRO-MUTTS SOCIETY (IAMS), Humphrey was much in the news a couple of years back, when the powers that be at the American Museum of Natural History peremptorily ruled that Pluto should no longer be regarded as a planet. Outraged, Humphrey yelped his dissent in gruff op-ed pieces and mounted a one-pooch picket line outside the museum's Rose Planetarium. (A photo of him wearing a sandwich board proclaiming "They can't be Sirius!" and, on the flip-side, "Dog Gone?" appeared on the front page of the New York *Post* above the headline "Boxer Rebellion.") Looking back on the uproar, he reflects, "My professional colleagues thought I was just being goofy, but I detected something sinister at work. There are cats in high places at that institution, and you can bet your life they wouldn't have tinkered with things had the outermost planet been called 'Sylvester.'"

Not that he hasn't done his share of celestial tinkering. Pursuing his own erratic orbit, Humphrey, as a young stargazer, decided that the zodiac was out-of-date and, as he put it in an early paper that remains a bone of contention in astrophysical circles, "anti-canine-ical." He proceeded to reimagine—and rename—the heavenly patterns along more dog-o-centric lines: the Scottie, the Airedale, and the Big and Little Poodles (or, to be more taxonomically precise, the Standard and the Toy). Unfortunately, Humphrey's newfangled scheme never caught on, though it was briefly employed by the horoscope column writer for the American Kennel Society newsletter.

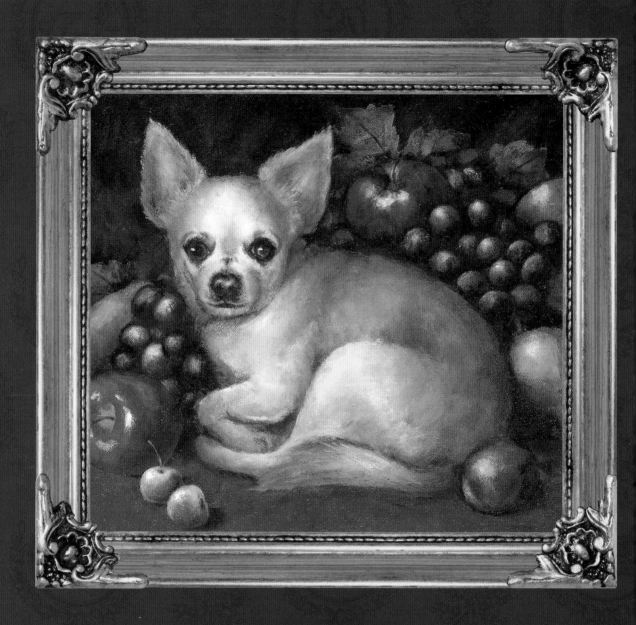

# ROSÌ

THOUGH LITTLE IS KNOWN WITH CERTAINTY of the life of the Italian Baroque painter Michelangelo Merisi da Caravaggio (1573–1610), one indisputable fact has come down to us: that Caravaggio was devoted to a chihuahua, Rosì, who was the artist's constant companion through the last dozen years of his checkered life. The dog, introduced to Caravaggio by his early patron Cardinal del Monte, apparently arrived in Rome along with the hoard of exotica brought back to Italy by a papal legate returning from Mexico City in 1597.

Vatican records disclose that Pope Clement VIII was possessed of a violent allergy to dogs, which may explain why Rosì was banished from the Holy City's precincts and fell into Caravaggio's company. And what strange company it must have seemed for this delicate creature, who had been reared in much more pampered surroundings. Caravaggio was a heavy drinker and gambler—a compromising lifestyle that regularly landed him in trouble with civil and religious authorities. Rosì, by contrast, was descended from a line that could be traced back to the court of the last Aztec king, Moctezuma II, and in all probability she had spent her puppyhood in the palace of the Viceroy of New Spain. Still, Rosì seems to have managed the transition from gilded salon to dirt-floored saloon with curious ease.

Zador finds Rosì's biography almost impossibly romantic. Caravaggio carried Rosì in a special pocket that he had sewn into his doublet, and Zador likes to imagine the tiny animal peeking out, quivering with concern as she watches Caravaggio losing at yet another game of knucklebones. When the inevitable brawl breaks out, she leaps from her hiding place, teeth bared, ready to tug at sleeves and nip at ankles—to do anything she can to assist her dissolute friend.

To celebrate Rosì's extraordinary life, Zador has chosen to portray her in a manner characteristic of the earliest phase of Caravaggio's career—a Bacchic still life infused with deep colors and the painter's trademark chiaroscuro. (The model is one of Zador's own closest canine chums, whose name—a provocative coincidence—is Rosie.)

# NIKKI

IN PARIS, THOSE WHO DON'T IMMEDIATELY RECOGNIZE HER are apt to mistake Nikki for a native. The insouciant style, the at-home way she stops traffic on the boulevards, the all-too-evident self-possession: everything about her seems to proclaim "Made in France." (This is assuming, of course, that Nikki doesn't demolish the illusion by attempting, say, to order herself a lamb chop at the local *boucherie*.)

Granted, there aren't too many who don't recognize the lanky, toothy, Indiana-bred platinum blonde, whose image, these days, is used to sell everything from herbal shampoo to her own line of diamond-studded flea collars. Nikki's become a one-bitch industry, whose annual gross is—well, let's just say it's a load.

Success hasn't spoiled her, though. To please the couturiers who helped her get a leg up early in her career, she still trots the fall- and spring-show runways in New York, Milan, and, of course, the City of Lights. And she still loves to horse around. Zador, who rarely works from photographs, couldn't resist basing Nikki's portrait on a silly snapshot of the model taken outside the gate of the Tombe du Caniche Inconnu—Paris's famed monument to the canine heroes of the Resistance. "I think there's a definite family resemblance, don't you?" Nikki coos. "After all, my ancestors came from around here someplace." She's so charmingly artless—and her good nature is so infectious—that even the stuffiest Gaullist would forgive her irreverence. When Nikki's in town, Paris burns with a pro-American fever not seen since the Liberation—or at least not since the French premiere of *The Nutty Professor.*

# MARCO

"**M**ODERNISM DEFINITELY WENT BARKING UP THE WRONG TREE," harrumphs Marco, the *enfant terrible* of society decorators who is as well known for the stratospheric fees he charges his pedigreed clientele as for the everything-but-the-water-bowl ensembles he crams into their Park Avenue parlors and Hamptons guest-houses. "All that Mies and Bauhaus stuff," he lisps, "—it's just not *comfy.*" And as those who know him well attest, Marco *loves* his comfort. "He's made the desire to lounge around doing nothing at all into the Guiding Principle of interior design," whispers one East Side clotheshorse who admits she has sometimes turned to Marco for advice.

Waddling onto the I.D. scene five years ago, Marco was quickly dubbed the "Prince of Prints" for his untamed addiction to vivid textiles—florid floral chintzes, seizure-inducing striped damasks, deep-pile leopard-skin velvets. "I call my design theory 'Mix and Don't Bother Matching,'" he opined in a piece commissioned by *Doghouse and Garden* magazine. "I don't stop with 'more is more.' I say, 'Too much is not *nearly* enough.'"

He also likes a house to look lived-in. "A little rumpled, just like me," he giggles. His shabby-chic proclivities, however, have won him as many detractors as fans. About one widely published Palm Beach sitting room that Marco tossed together, a tidy-minded architectural writer declared, "It goes way beyond mangy. It's positively *flea-bitten.*"

# BEAU

CONFIDANT OF ROYALTY AND INTIMATE of artists, politicians, and sundry of the idle aristocracy, Beau was the most eminent of canine Victorians. Himself born to privilege and indolence, he nevertheless believed that every young dog should have an occupation. And so he decided to become a gadfly, a social *provocateur*, . . . in other words, a real scamp.

This dandy dog's uncurbable wit was justly celebrated. When urged to comment on the installation of the British capital's first fire hydrant, he pronounced the event "the most glorious moment in the history of civilization." Asked to opine on the matter of a gentledog's proper attire, he rejoined, "I believe that tails are suitable for any occasion." But he knew his limits: when one admirer compared his *bons mots* to those of the great Oscar, Beau demurred: "My dear lady, I am not Wilde. In fact, I am quite domesticated." It's no wonder historians have declared that Beau's era was truly a doggie day in London town.

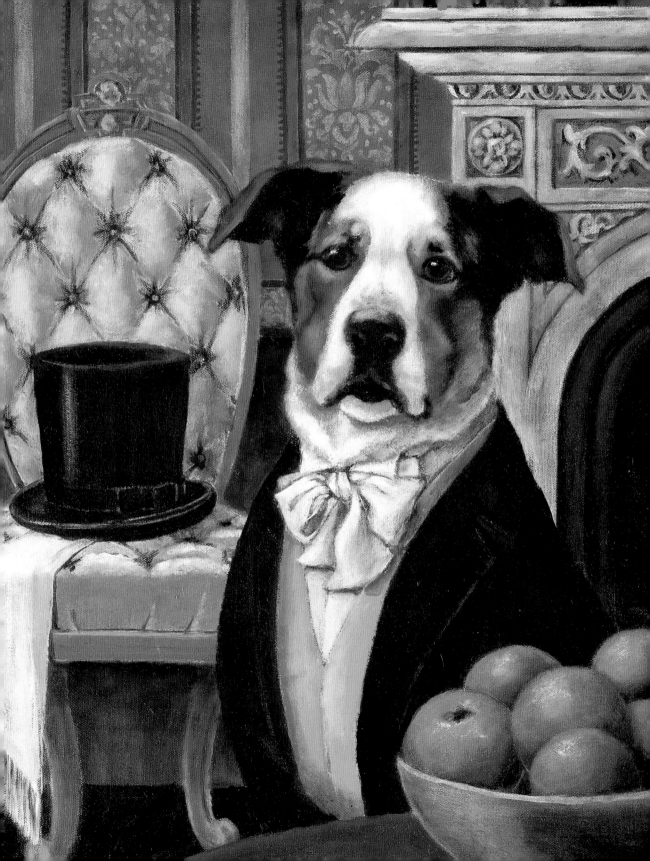

# BERNARD

BERNIE IS IN A FUNK, WHICH ISN'T UNUSUAL. Bernie's *been* in a funk. You'd think an artist who's been riding the gravy train of critical acclaim as long as Bernard has would be a bit more upbeat. You'd think a painter whose merest paw print commands something in the six-figure range would be, well, a little easier on himself. But no.

His work lacks integrity, he tells interviewers. He's lost his style, he says. Artistically, he's washed up, a has-been, a dead dog. And then he pulls together a show—a mongrel collection of Pollock-like, slobbered-all-over canvases and tortured, Bacon-esque self-portraiture—that leaves the postmodernism-mavens at *ArtForum* panting for more. "Our era's master appropriationist," they coronate him. Even the *Times* is more than kind: "Talk About New Tricks!" declares the headline above chief art critic Kibbleman's effusive review.

All those doubts and self-excoriations are, of course, a pose. Those who know Bernie well will doubtless detect just a glimmer of satisfaction in that hangdog expression.

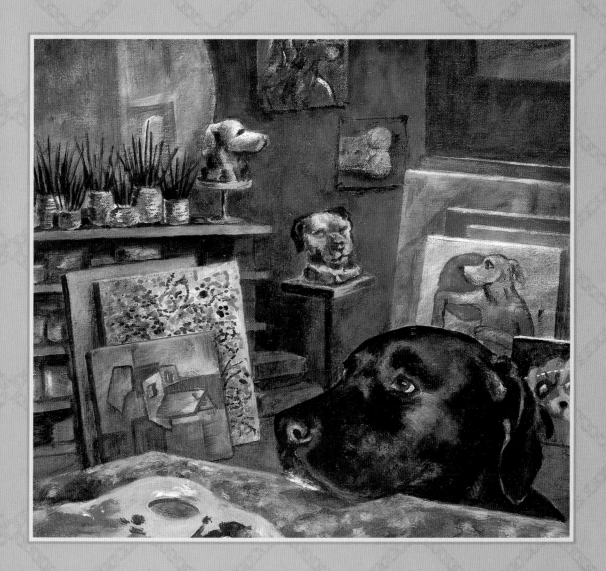

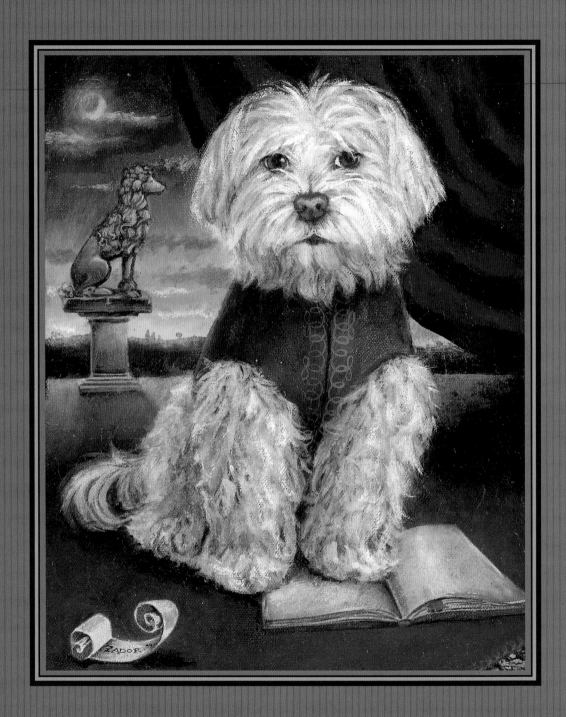

# TOBY

Venice is a town for dogs—and never more so than during its annual Canicola ("Dog Days") Festival, held each August. Zador and her companion Toby first became aware of the celebration a few summers back, when they were on their first Grand Tour of Italy together. They happened to arrive in the water-logged city just in time to catch the Canicola's main event—the Pigeon Chase across the Piazza San Marco. Toby, who—except for the couple of pleasurable hours he'd spent snuffling around the catacombs outside Rome—hadn't much been enjoying Italy, was enraptured.

At Toby's insistence, Zador and he have since made several return visits to the Queen of the Adriatic. Venice aficionados won't be surprised to learn that Toby's love of the city has deepened and grown more complex over the years. In Venice, joy is eternally accompanied by an undercurrent of melancholy—a kind of sinking feeling, as Toby describes it. "Going there always puts him in a very pensive mood," says Zador, which is why in this portrait she chose to depict him, garbed in a velvet jerkin, as a philosopher of the Venetian Renaissance. Visible through the curtained doorway and shining in the light of the moon rising over the Lido is Bernini's famous monument to the poodle Ercole, long honored by Venetians as a defender of their democracy. The statue's presence in the picture is Zador's nod to what first thrilled Toby about Venice. Civic lore has it that it was Ercole who established the Dog Days games—to celebrate the city's 1471 victory over a marauding fleet of Genoese barks.

# EDWIN

WAS SHAKESPEARE FOND OF DOGS? The issue has long troubled—and divided—literary scholars, with the anti-canine school pointing out that the Bard uses the word "dog" mostly as a derogatory epithet, while the dog-loving camp relies on lines like this one, from *The Merry Wives of Windsor,* to make its case: "He's a good dog, and a fair dog: can there be more said?" This bitterly argued dispute, which shows no sign of being resolved anytime soon, is enough to make one "dog-weary" (*The Taming of the Shrew,* Act IV, scene 2).

An easier question might be, "Are dogs fond of Shakespeare?" To judge from the long line of actor-pooches who've specialized in the Shakespearean canon, the answer can only be a resounding "You bet!" There's evidence that the resident troupe at Shakespeare's own Globe Theatre provided not-infrequent employment to four-legged thespians, including a shepherd bitch called Eleanor who could bark in iambic pentameter and who, when called upon to fill in for one of the troupe's preadolescent boys when his voice unexpectedly broke, performed a passable Ophelia. (Her Mad Scene, apparently, was especially convincing.)

By far the most renowned, though, of the Bard's canine interpreters was Edwin, whose national tours of his one-greyhound medley, "Tragickal and Historickal Soliloquies of Mr. Wm. Shakespeare," was as famous, in its day, as P. T. Barnum's Circus or Buffalo Bill's Wild West Show. Edwin's histrionics were legendary: He chewed the scenery in municipal opera houses from Terre Haute to San Luis Obispo, causing no less a wag than Mark Twain to quip that Edwin had "put the 'ham' in *Hamlet.*" Zador's portrait—emphasizing the magnificent profile that broke small-town hearts all over America—shows Edwin outfitted for his favorite role: Prince Hal in *Henry IV, Part II.*

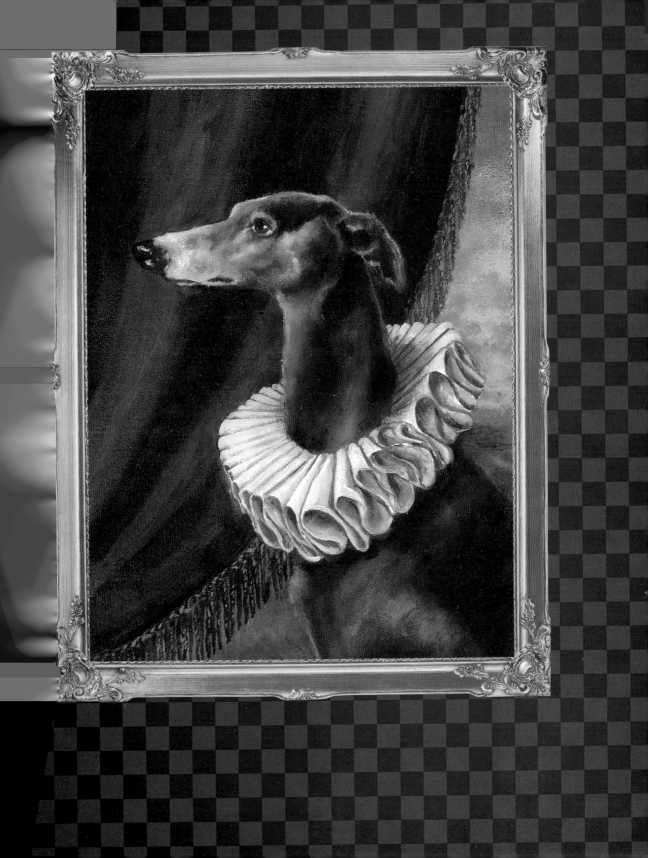

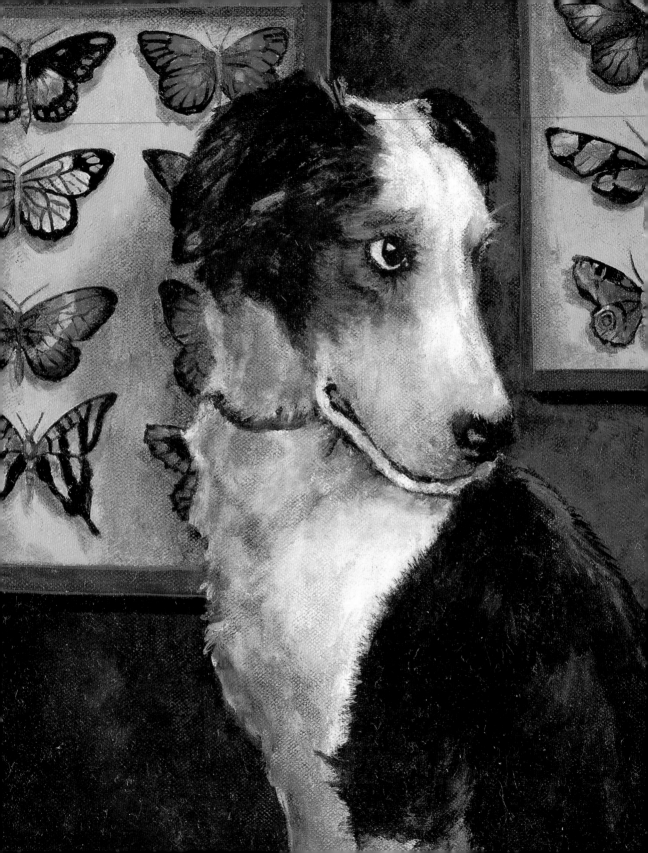

# VLADIMIR

"VLAD THE IMPALER," his friends call him. Oh, yes, his butterfly chasing is *only* a hobby, but Vladimir's pinned more specimens than many an entomologist who draws a natural history museum paycheck. Of course, he writes novels, too, and his books have not only drawn critical applause—they've been best-sellers. When asked about them, however, he's dismissive: The royalties pay the bills and help him support "his habit," as he refers to his curious ardor for the order Lepidoptera.

Though the general reading public is hardly aware of his scientific achievements, his scholarly papers—including the still-controversial "Butterfly Development: The Nymphet Stage"—are required reading in insect-biology courses from Beardsley College to the University of St. Petersburg.

In his autobiography *Sit, Roll Over, Speak, Memory!* Vladimir confesses that the moments in life that have given him the greatest pleasure have been those when he's fetched a hitherto-unknown species. The one he's proudest of nabbing (you can see it there in the case, just above his left eyebrow) is the Zemblan Monarch, named for the little-traveled European land where he made the catch. "That fey pattern on those weirdly attenuated wings—it's quite delightfully insane, don't you agree?" he asked Zador when she visited him at his chalet retreat in the Swiss Alpos. It was there, in what he calls "my little cocoon," that she painted him, alongside his trophies.

# MISTER CHURCH

**T**ALK ABOUT A BULLDOG IN A CHINA SHOP. Of all the hard-bitten dealers who tote their rare wares to the Winter Antiques Show, Mister Church has the reputation for being the most pugnacious. His pieces typically fetch such astronomical sums that insiders credit him with single-pawedly driving up the world market in Staffordshire salt-glazed spaniels. His selling style is as polished as the porcelains, brasses, and suchlike that are his stock in trade. "I'm not operating a flea market," he explains. "I name a figure, and if they want it, they pay it. My regular clients know they're getting top value. The name's Church, not Church Rummage Sale."

Despite his disclaimer, the prices he charges his customers are equaled—on the outrageousness scale—by the bargains he extracts from the impoverished gentry and down-on-their luck dot-commers who keep the treasures flowing into Mister Church's tasteful emporium on that upper-crusty retreat off Cape Cod. He's so cutthroat that pickers refuse to deal with him, and more than once Zador's heard the limerick that circulates about him:

> *There was an old pug from Nantucket*
> *Who so hated to part with a ducat*
> *That he'd blackmail his mother*
> *Or smother his brother*
> *For a Waterford crystal ice-bucket.*

Of course, he does have some very nice things. Not that Zador could ever afford to pay cash for them. But when, browsing in Church's store, she spied a pair of irresistible little footed bowls from the Chow dynasty, she conceived a plan. Why not a portrait in exchange? Church, whose avarice is matched only by his vanity, was quick to agree.

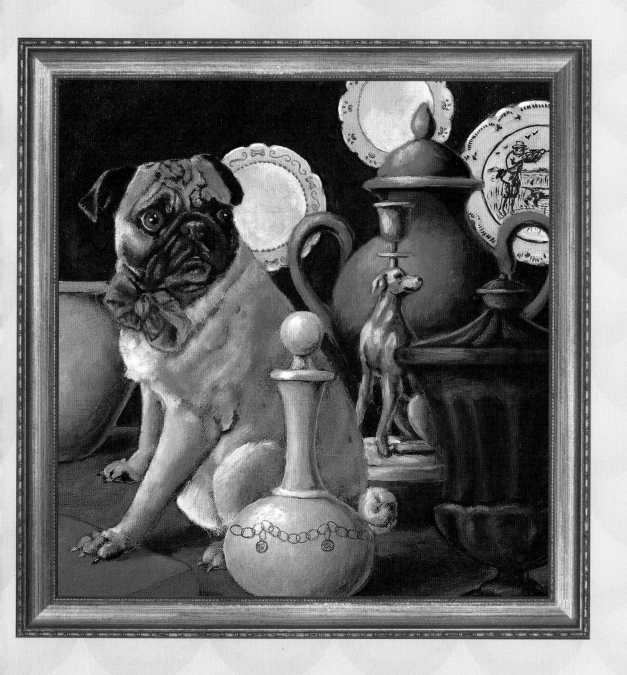

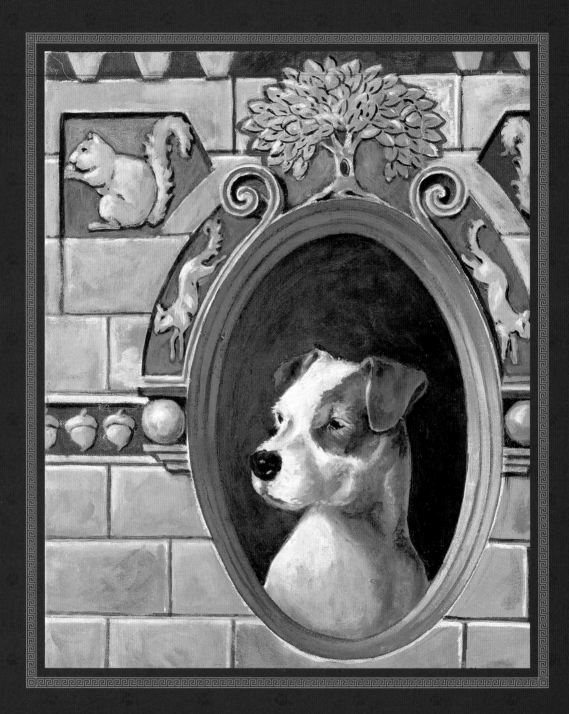

# H.H.

HOW MUCH IS THAT DOGGIE IN THE WINDOW WORTH? That's hard to say, but the fortune's grand enough to keep a pack of architects, stonemasons, and sundry craftsmen frenetically dashing about. Once it's completed, the Romanesque Revival pile—The Burrow, he calls it—that he's depositing amid the manicured lawns of his Kentucky bluegrass country estate will trump any of the Gilded Age foxholes of Morgan, or Vanderbilt, or Hearst. This doghouse, friends, is no dump.

By all accounts, H.H. is not an easy client. A stickler who insists on overseeing the execution of each architectural detail, he also keeps an all-seeing eye on every penny spent. More than one contractor has departed in fury over his untrusting approach to employee relations. "He just digs and digs until he finds something, and then he drops it at your feet with that 'Gotcha!' look of his. I couldn't stand being hounded like that, so I quit," says one disgruntled former construction manager.

Though he shows it to few, H.H. *does* have a sentimental side. It's revealed, for example, in the squirrel-and-acorn motif that dominates the house's façade. He ordered it because he wanted to be reminded of his idyllic puppyhood—those long August afternoons he spent pursuing nervous, helpless prey and rooting out the small provisions they'd laid aside to get them through the winter. "Come to think of it, it wasn't bad training for my future career," says this Captain of Industry, with a suddenly wolfish grin.

# OLLIE AND TIFF

They're brother and sister, though they don't look alike, sound alike, think alike. One's on the left, the other the right. Ollie's the knee-jerk, bleeding-heart type. Tiff—the beribboned, oh-so-ladylike one—is the rabid conservative. Their daily call-in show, *Dogfight,* is the biggest thing to hit the airwaves since *Rin Tin Tin.*

Every program is a pointer–counter-pointer free-for-all. He's for rewards-based education; she's for obedience training. He's for running free; she's for a tight leash. He's for distributing biscuits to the Afghans; she's for beefing up the K-9 Corps. He barks; she bites. Boy, can it get rough. "You just like to hear yourself yap," he tells her. "Muzzle yourself," she replies. "You're a regular pit bull," he says. "Your name should be 'Old Yeller,'" she rejoins.

In private life, of course, they are devoted to one another.

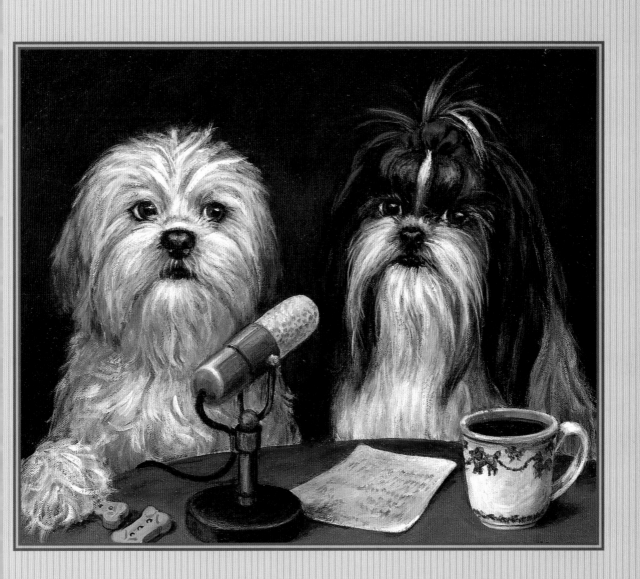

# DUNCAN

No tim'rous beastie he, Duncan's truly in his element when he's out on the moor. December's winds and winter's sleety dribble, he insists, are just the thing to flush out a hangover. He is, of course, a poet. His collection of brogue-inflected doggerel, *The Hair o' What Bit Thee,* has brought Scottish (or is it Scotch?) literature to a pub-crawling level not seen since *Trainspotting.*

When Zador, with companions Toby and Bingo in tow, paid him a visit last year, the cairn-terrier bard revealed himself to be an ingratiating host. "What a highland fling we had!" exclaims Zador, who'll never forget the views across the Firth of Forth, the haggis-and-kippers breakfasts (Toby loves the stuff), or the long northern afternoons spent playing the links at Dornoch (Bingo caddied). Her one regret was not discouraging Duncan from taking Bingo scooby-diving in Loch Ness, in an ill-considered mission to rouse the famous monster. Poor Bingo! Emerging muddy and shivering from those murky, glacial waters, he let out a pitiful yelp that echoed from glen to glen. He soon recovered, though, when the troupe visited Duncan's favorite distillery in his ancestral village on the Isle of Skye. (To Zador's amazement, both Toby and Bingo turn out to be single-malt types.)

Duncan likes Zador's portrait, though he seemed perturbed by a remark she made when presenting it to him. "You remind me of another of my literary heroes—Heathcliff," she said, thinking to compliment him. "Are ye daft, lassie?" Duncan responded. "Heathcliff was a Yorkshire!"

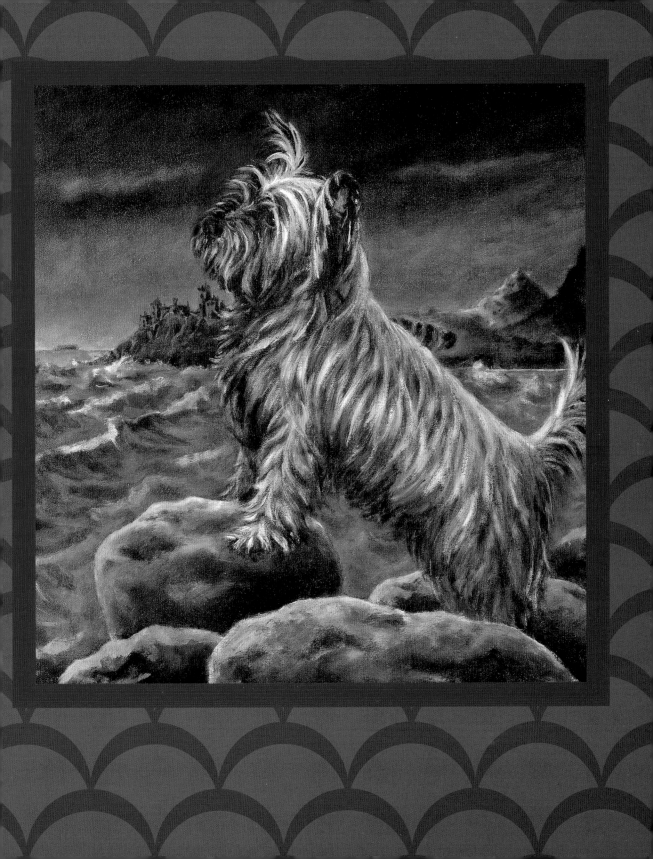

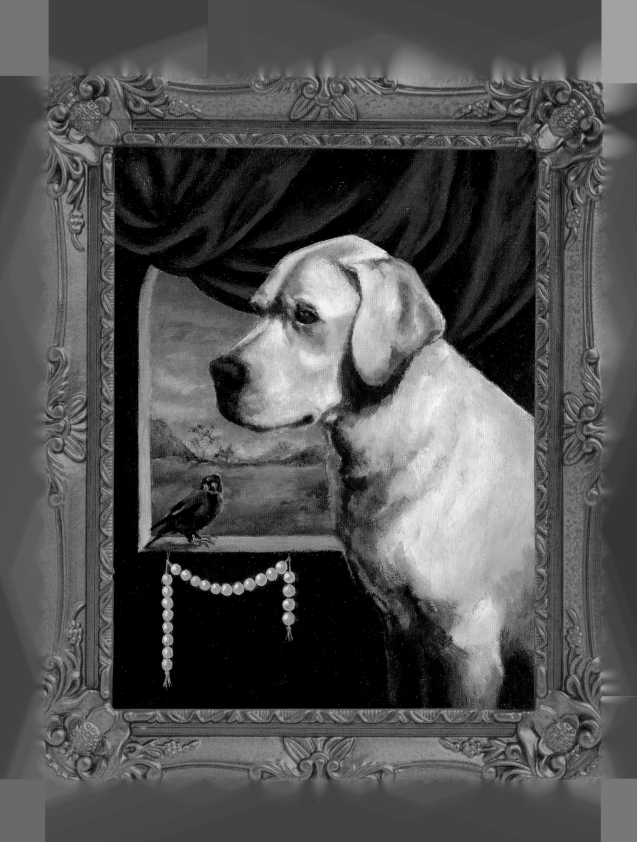

# ALFRED

**A**LFRED WAS AT FIRST PUZZLED by Zador's portrait of him. It was obviously an allegory, but it took him a while to figure out what the various elements meant. The view through the window was the easy part. "That's my love of adventure," he says. "You'll notice it's not one of those domesticated landscapes you see in Renaissance portraits. It's wilder, with no well-trotted paths."

Venturing into the unknown is certainly an apt metaphor for Alfred's celebrated mid-career move. In a decision that had publishing-world tongues wagging, Alf left his high-power editorial post with a top commercial house, breaking with the book industry's big-dog-eat-little-dog ethos and striking out on his own. His independent imprint, Publishing Lab, stunned the naysayers by issuing three best-sellers during its first season.

The sparrow gave him more trouble. "It finally dawned on me that the little bird represents our 'all creatures great and small' approach." Indeed, a willingness to bring a diversity of voices (and barks, and oinks, and twitters, and, yes, even the occasional meow) into print has been Publishing Lab's mission from the start. "Other editors gather a stable of writers around them," he says. "With us, it's been more of a menagerie."

The pearls, however, stumped him. Did they stand for culture? Were they "pearls of wisdom," perhaps? Frustrated, he took his lame guesses to Zador. "No, silly," she giggled. "They only mean that you really like oysters!"

# CLARKE

IT'S CLARKE'S PET PEEVE. As far as he's concerned, the United States always lagged far behind the Soviets in the space race. "The Kremlin knew which species had the right stuff," he says. "Between '57 and '66, the Russkies blasted thirteen Muttniks into orbit. Sure, we put a man on the moon, but those borzois were howling at the stars."

Clarke's always been lost in space. As a pup, he could never understand why the cow got to jump over the moon while the little dog just hung around laughing about it. Watching his friends play Frisbee, he'd lie on the grass imagining himself inside the brightly colored saucer, breaking the sound barrier, then hurtling into the universe's uncharted reaches. When it came to his career, Astro-physics was nothing short of destiny.

He's dedicated his professional life to putting NASA on the dog-track. After years spent begging at congressional committee tables, his day has finally come. *Rover 1,* the first intergalactic vehicle piloted by a canine, is now in development—under Clarke's direction, of course. His ultimate goal: the discovery of intelligent creatures on other planets. "You can bet we'll sniff 'em out," he says, "and they won't be of the two-legged variety, either."

Zador has a soft spot for the geeky types—thick glasses and a pocket protector send her into the stratosphere—so she was thrilled to be asked to paint Clarke at work in his laboratory. Now she's even more excited: He's personally invited her to attend *Rover's* launch, at Cape Canineveral.

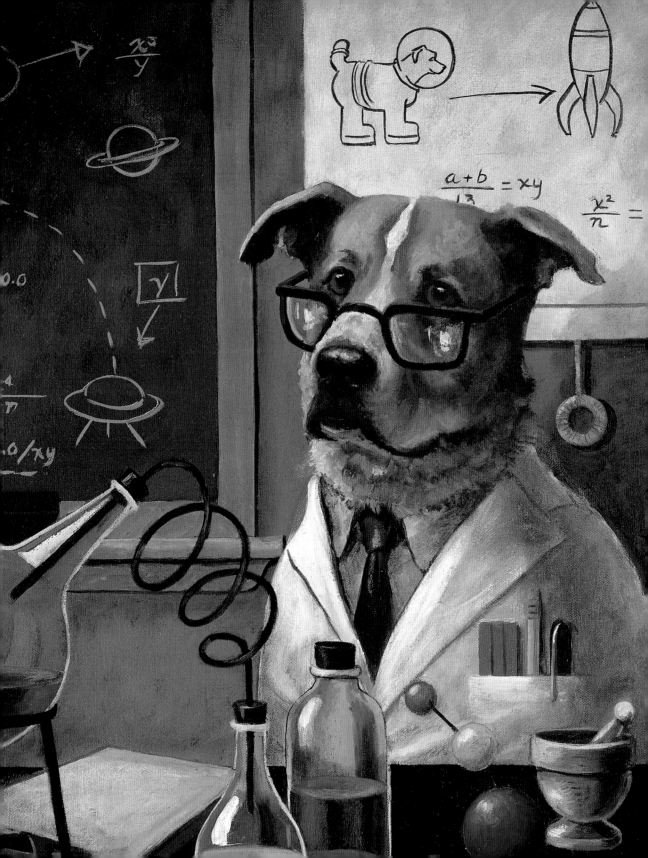

# THE RECLUSE

H IS GLORY DAYS ARE OVER, and he doesn't venture out any longer, except for his early morning tonic and the midnight strolls along the promenade. He's "retired," he tells the handful of friends who visit—taking time, he says, to enjoy his memories and his "things." And what things they are, these bibelots and *objets* gathered over generations of globetrotting and high adventure. (It's rumored, nastily, that curators from Houston to Prague are already salivating, anxious for the day when he announces that he's "considering" donating the collection.) The jewel in the crown, of course, is the portrait of his great-great-grandfather—the dashing young pointer, executed in bronze by Lachaise—that graces a window in the family brownstone where he now dwindles, alone.

Zador had always wanted to meet him, but access proved difficult. She made inquiries through friends of friends, but was rebuffed. Finally, a young cousin—Zador had run into him at one of those Virginia hunt club things—secured an interview. Zador's nervousness was unwarranted. The Old Boy turned out to be surprisingly gracious, and, after an hour of conversation, Zador felt comfortable popping the question. Would he sit for her? Yes, was the reply, with one condition—that his name not be attached to the portrait. He wants, he confessed, to be remembered for what he was, not what he has become. Silly, sad vanity. As if we wouldn't recognize that profile *immediately.*

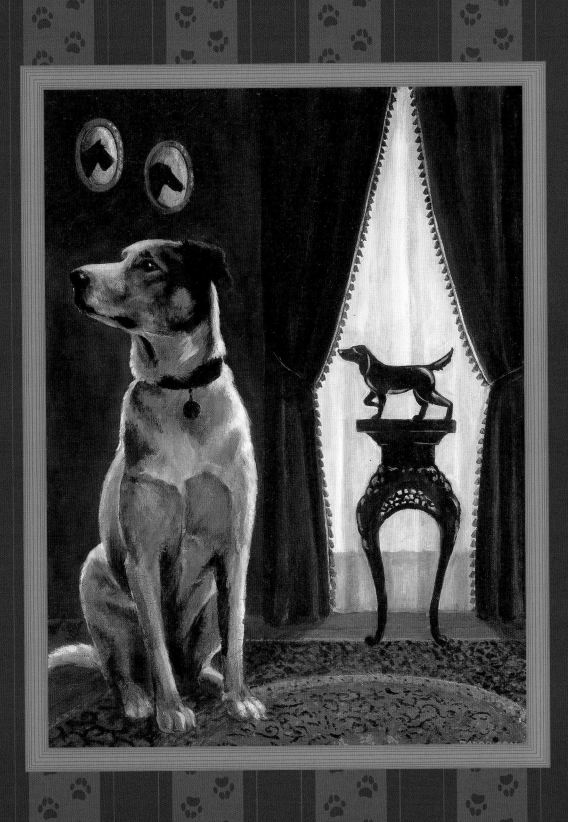

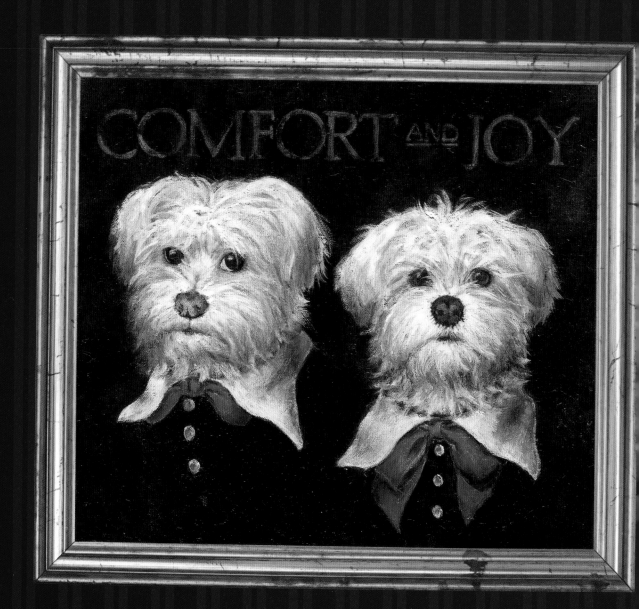

# TOBY AND BINGO

IT'S A COZY DOMESTIC SCENE: Bingo is sprawled on the rug near the hearth, fiddling with some Scrabble tiles and figuring out that P-U-P is a palindrome. Toby, a notoriously picky eater, is cautiously licking at a slice of mincemeat pie. Zador is putting the finishing touches on the tree, making sure that at least a few ornaments (the plastic ones!) are low enough for B. and T. to knock off and play with. By the chimney, she's hung their stockings with care.

'Tis the night before Christmas, and all through the apartment building, all through the block of Greenwich Village rowhouses that it adjoins, and all through the wide city beyond, creatures are stirring. People and dogs and cats (and undoubtedly quite a few monkeys, parrots, ferrets, boa constrictors, guinea pigs, budgies, and iguanas, as well) are decking the halls, setting out the bowls of brandy-laced eggnog and plates of fresh-baked biscuits, making ready for the visit of Rudy, the Great Husky of the North. Tonight, he'll be mushing into town, tugging his dogsled laden with squeaky toys, rubber balls, rawhide bones, rattles, catnip mice, Frisbees, rhinestone collars, silver-plated dogtags, and—for the iguanas—Chinese-takeout cartons full of tasty, crunchy mealworms. (Even the Great Husky finds it hard to know what to get for an iguana.)

An hour later, and the Zador household is quiet. Toby and Bingo—Zador's own Comfort and Joy—have snuggled down and are snoring rhythmically. Zador, of course, is wide awake, lying very still until she's sure the boys have dozed off. Her work, she thinks, is just beginning. She dreads the day when she'll have to tell B. and T. that there is no Great Husky. She climbs from bed, steps softly into the parlor, looks around, trying to remember where she's hidden their gifts. It's just then that she hears a gentle scratching, an importuning whimper—issuing, it seems, from the fireplace . . .

# DOG-SITTERS

"Hilda" is actually Ludwig ("Luddie"), a handsome red dachshund—and a rescued stud dog—who with his canine sister, Charlotte, lives with Christopher Surridge.

"Humphrey" is Max; the boxer lives with Robert Dessau and Manuela Kolb in their Greenwich Village apartment.

"Rosi" is Rosie, a rescued chihuahua who lives with Christine Rodin, a New York photographer.

"Nikki," whose real name was Baby, remains an enigma; the artist found her in an old photograph of unknown origin and was intrigued by her light-hearted appearance.

"Marco," in real life, is Tina, the beloved sharpei of Ron Chereskin and Howard Goldfarb.

"Beau" is Chance, who was living at the New York City Humane Society when he sat for the artist. His dashing good looks so inspired her that she used him twice. (Chance is also the model for "The Recluse.") Happily, he has since been adopted.

"Bernard" is Gus, beloved companion of Leslie Stoker (and also a rescued dog).

Toby appears as himself. The artist adopted the Maltese in 1995, when he was six years old—proof that even older adopted animals make wonderful pets. Toby provided the original inspiration for the artist to begin painting animals, and she remains forever indebted to him.

"Edwin" is rescued greyhound Chaz, whom the artist met and photographed while walking in Greenwich Village.

"Vladimir" is Lucy, a former Humane Society resident whose soulful expression and gentle nature captivated the artist. She has since been adopted.

"Mr. Church" is Oscar, a gem of a pug who makes his happy home with Allison McCarthy in Greenwich Village. (He and Bingo have become close friends.)

"H.H." is a Jack Russell terrier (real name unknown) whom the artist photographed while he and Bingo played together in Central Park.

"Ollie and Tiff" are, in fact, Oliver and Tiffany. The shih tzus are very close to the artist indeed, as they make their home with her sister Karen Berretta and her family in New Jersey.

"Duncan" is Rocky; the cairn terrier lives with Linda Tepper and Steven Abrams in their Manhattan apartment.

"Alfred" is Romeo, a prince among yellow Labradors. He makes his home with neighbors Peter Arnold and Tim Braun, and the artist has known him since he was a puppy.

"Clarke" is Indiana. The artist made his acquaintance at the Humane Society, and she was immediately taken with his intelligence and "scientific" curiosity.

Bingo unexpectedly entered the artist's life in early 2001, a gift from her dear friend Emmett McCarthy. Bingo has become a gentle, loving companion to Toby.

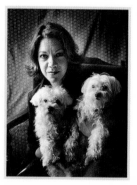

LISA ZADOR, a native of Philadelphia, received her BFA from the Philadelphia College of Art. A textile designer and illustrator, she has worked for numerous top clothing designers, and her illustrations have appeared in *Harper's* and other magazines. In 2001, Stewart, Tabori & Chang published boxed sets of her "Swingers" and "Babalu" cards. She lives in New York City with her companions, Toby and Bingo.

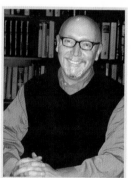

JAMES WALLER is a writer and editor who lives in Brooklyn, New York. He is the editor of the *National Writers Union Freelance Writers Guide* (F&W Publications, 2000) and the writer of the *Moviegoer's Journal* (Stewart, Tabori & Chang, 2001). He teaches writing at Brooklyn's Polytechnic University.